World Make Way

New Poems
Inspired by
Art from
The Metropolitan
Museum of Art

EDITED BY LEE BENNETT HOPKINS
PUBLISHED WITH THE METROPOLITAN MUSEUM OF ART

ABRAMS BOOKS FOR YOUNG READERS
NEW YORK

Previous page: *Untitled (Studio)* 2017. Detail.
Pages 2 and 3: *The Repast of the Lion,* ca 1907. Detail.

Cataloging-in-Publication Data has been applied for and may be obtained from
the Library of Congress.

ISBN 978-1-4197-2845-7

For poetry and art credits, please see page 46.

Foreword copyright © 2018 Lee Bennett Hopkins
Copyright © 2018 The Metropolitan Museum of Art
Book design by Jay Marvel

Printed and bound in China
10 9 8 7 6 5 4

Abrams Books for Young Readers are available at special discounts when
purchased in quantity for premiums and promotions as well as fundraising or
educational use. Special editions can also be created to specification. For details,
contact specialsales@abramsbooks.com or the address below.

ABRAMS The Art of Books
195 Broadway, New York, NY 10007
abramsbooks.com

To Steven Herb—

who enriches lives
with the art
of his being.

—LBH

"Painting is poetry that is seen
rather than felt,
and poetry is painting that is
felt rather than seen."

—LEONARDO DA VINCI

Foreword

LEONARDO DA VINCI (1452–1519) was an important figure during the Italian Renaissance (roughly 1300–1600), a period when art flourished in Europe. He was a master in many fields: painter, sculptor, architect, engineer, writer, poet, and others—his genius epitomized the Renaissance. *A Bear Walking* is among one of his abundant observations of the natural world. Though rough, the sketch reveals sharp details of the animal's strong facial features, powerful muscles, and grasping claws—a stance as if the bear forewarns: *World make way!* In the quote on the facing page, Leonardo's words ring true of all art, be it a vast canvas created by the contemporary artist Kerry James Marshall, a painted plaster pavement fragment uncovered from ancient Egypt, or a fanciful Mexican wood engraving depicting skeletons as artisans.

When you look at art, you may see and feel things differently than your friends or classmates. You might focus on a work as a whole, or you might zero in on a small detail that jumps out—a patch of sky, a sailboat, even a swirl of color. Looking at a work of art can produce a range of emotions and reactions. It can make you happy or sad; make you laugh, think, ponder, or wonder. *World Make Way* features eighteen poems especially commissioned for this book, written by contemporary poets. Reaching deep within their hearts and souls, each poet interprets what they unearthed after viewing a specific artwork. The artists and their artwork stem from many parts of the world, were created at different times in history, and depict a variety of subjects. A wide range of mediums—such as oil paint, pencil, and ink—were used as well. The pictures capture your eye, just as the poems capture your ear.

Through poetry and its richness of language, we can "row on our way . . . into the shadows of a water colored world," be like a bat who rules "hours of darkness," and find "cornflowers turn to tufted stars."

Art brings such riches. Poetry elicits such language. Mesh both together, and magic happens. Yes, it is, as Alma Flor Ada admonishes:

> **"everything else forgotten**
> **unimportant**
> **like scattered litter strewn**
> **on the dance floor."**

What have these poets seen? What do you see? What do you feel?

Lee Bennett Hopkins
Cape Coral, Florida

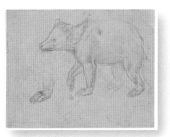

A Bear Walking,
ca. 1482–85
Leonardo da Vinci
Italian
Silverpoint on
light buff prepared paper

Mäda Primavesi, 1912–13

GUSTAV KLIMT

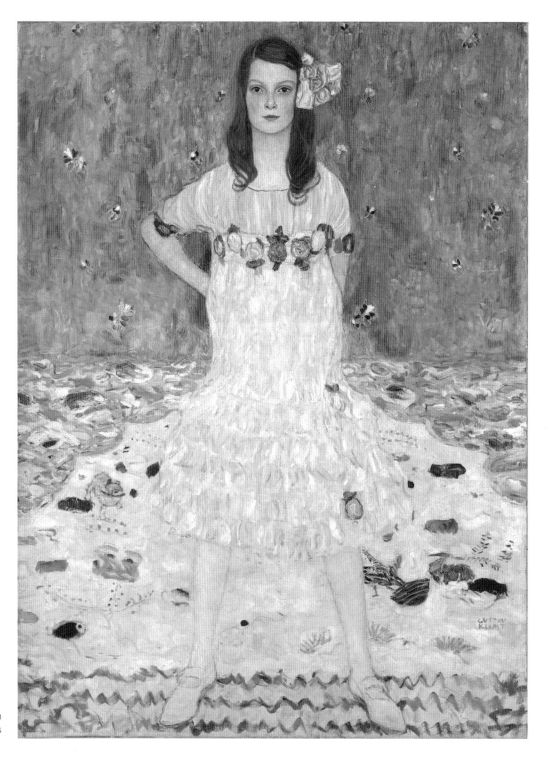

Austrian
Oil on canvas

Paint Me

MARILYN SINGER

Hurry up and
 paint me.
I have things to do,
more than you.
Streets, countries, continents to see
outside of this atelier.

I cannot spare more hours.
I'm tired of this dress, these flowers.
I'm young, a girl, it's true,
but I insist,

 World, make way.

You've captured my expression
and the way I hold my hands.
So, dear old man, please end this
session.

Hurry up and
 paint me.

Finish today!

Blue Worlds
REBECCA KAI DOTLICH

I grow up in a world the color of water.
Sometimes when breezes blow just right,
when sun puddles in blue folds,
mama talks of blue things, wild things;
seaglass and butterflies,
peacocks and poppies.

While clocks keep perfect time
ships sail on seas yet named,
and birds sing odes to skylight.
Cornflowers turn to tufted stars
while mama threads light rain,
stitching my name
into air.

Young Mother Sewing, 1900
MARY CASSATT

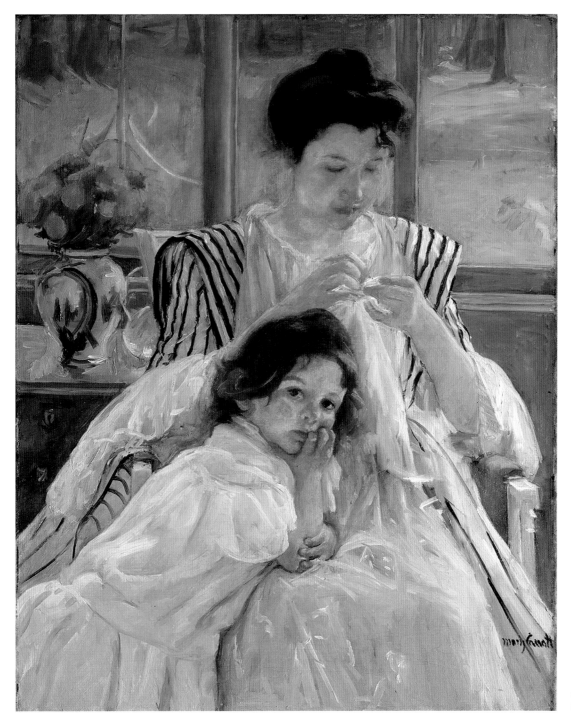

American
Oil on canvas

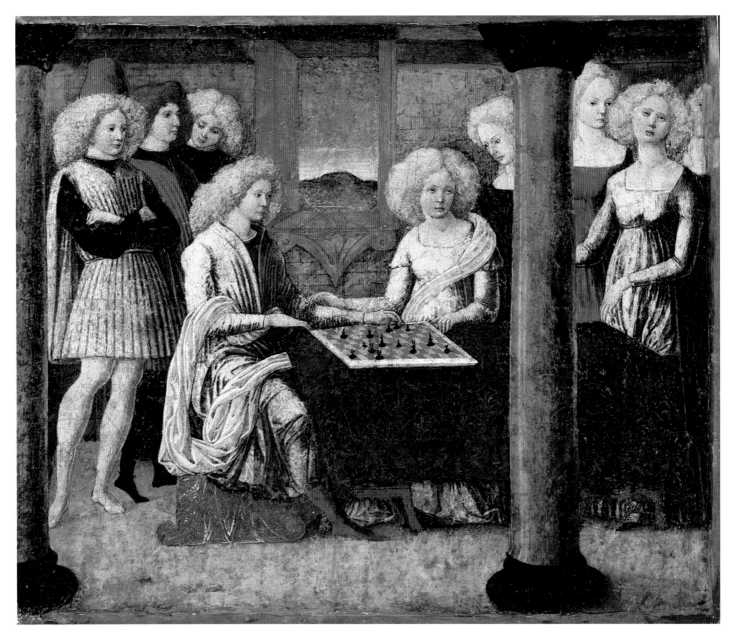

The Chess Players, **ca. 1475**

LIBERALE DA VERONA

Italian
Tempera on wood

Endgame
LEE BENNETT HOPKINS

Stay alert—
 do not divert
 do not stare away.
 The object
 of this game
 is to
Concentrate
 on every play.

Think as I do
methodically,
as I exploit
your weakness
while you peer at
what is unclear
you are looking for
near the door.

This is far too easy
knowing you are
about to lose.

Soon.
Within a flash,
a dash,
our date will end.

Checkmate, my dear.
Checkmate.

Young Ashoka Sundari
AMY LUDWIG VANDERWATER

I stand behind this neem tree
to watch my parents play
a game of chaupar
on a tiger rug
beneath bright mango sky.

They do not know I listen.
I watch as they take turns.
I see my father
win the long necklace.
I hear my mother sigh.

Little tiles move back and forth
as sunshine warms my hair.
Sometimes Father wins.
Sometimes Mother wins.
Each noon I watch their game.

Will I find a good husband?
Will we play chaupar too?
On a tiger rug?
Under mango sky?
When will I learn his name?

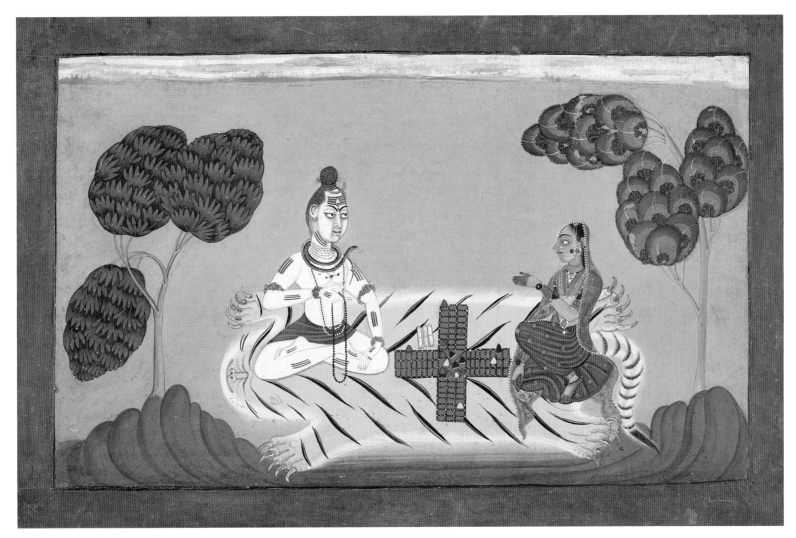

Shiva and Parvati Playing Chaupar: Folio from a Rasamanjari Series, 1694–95

DEVIDASA OF NURPUR

Indian
Opaque watercolor, ink, silver, and gold on paper

Dancing
ALMA FLOR ADA

Music fills the room
as we play.
Seven of us grow
taking up all the space
leaving only enough room
for a couple to dance
with quick steps
her hair flying
in abandonment.
Two absorbed by our music
which continues to take over the world
everything else forgotten
unimportant
like scattered litter strewn
on the dance floor.

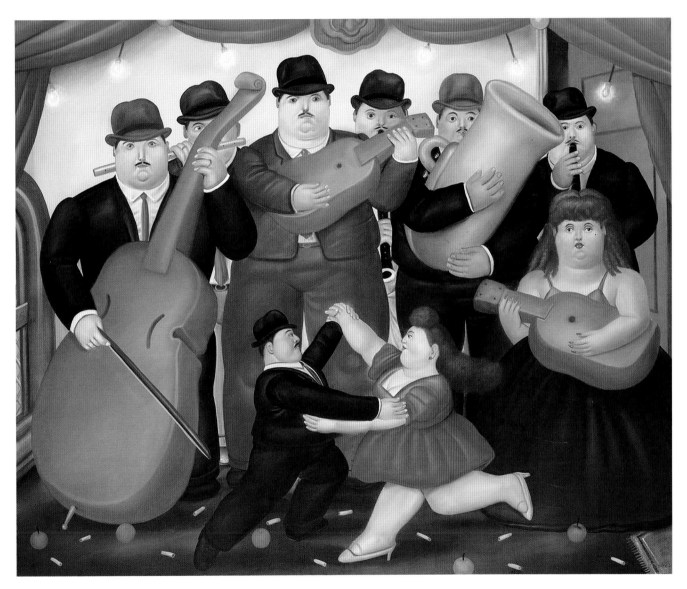

Dancing in Colombia, 1980

FERNANDO BOTERO

Colombian
Oil on canvas

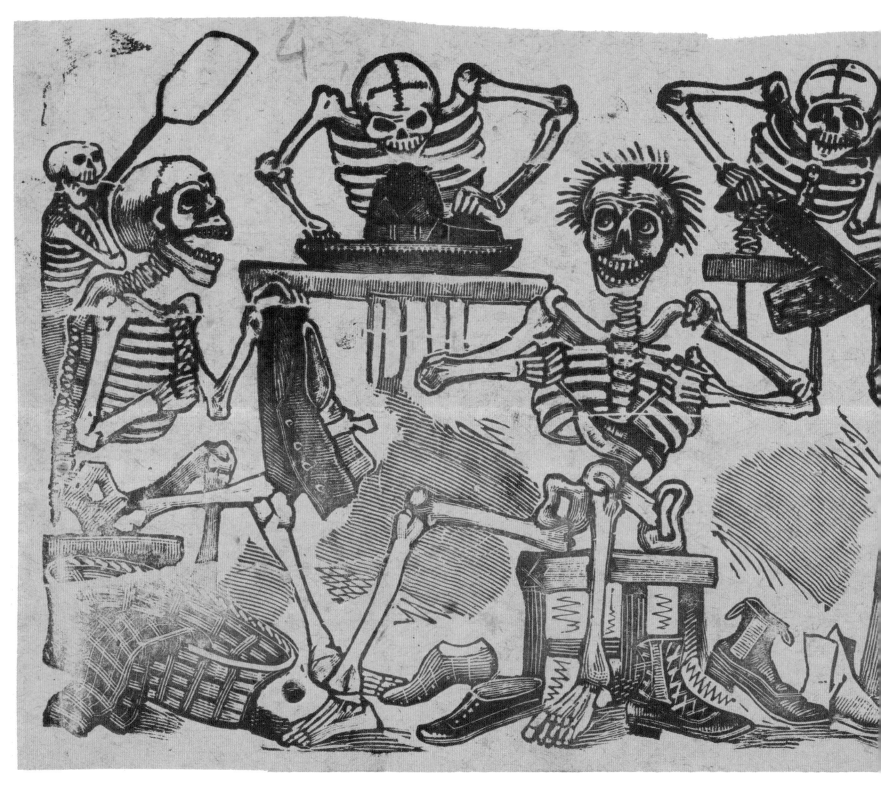

Skeletons as artisans, **ca. 1890–1910**

JOSÉ GUADALUPE POSADA

Mexican
Wood engraving

Ti-ki-ri, ti-ki-ri, ti-ki-ri, tas!
GUADALUPE GARCIA MCCALL

Ti-ki-ri, ti-ki-ri, ti-ki-ri, tas!
Look at our boney frames
move up and down, swivel and slide.
As we rip and pull and toil through rain,
we saw, saw, saw through all our pain.
> Look at how hard we work.
> Look at how trained we are.

Ti-ki-ri, ti-ki-ri, ti-ki-ri, tas!
Look at us lift our humerus over
our skulls. We hammer and beat.
We breathe life into molten glass,
emboss leather, and buff out brass.
> Look at how fast we work.
> Look at how practiced we are.

Ti-ki-ri, ti-ki-ri, ti-ki-ri, tas!
Look at us fret and sweat.
This is how we earn our bread.
Our bare phalanges twirl the needle,
pinch the fabric, crimp the cloth.
> Look at how quick we work.
> Look at how skilled we are.

Ti-ki-ri, ti-ki-ri, ti-ki-ri, tas!
Look at us tamp down felt,
iron the brim, brush the ribbon,
and polish the crown. We whistle
and smile as we craft and style.
> Look at how well we work.
> Look at how proud we are.

This is how we'll touch the sky,
Outrun the wind, outshine the sun.
Ti-ki-ri, ti-ki-ri, tin, tin, tin!

Pelando dientes.

Tas, tas, tas!

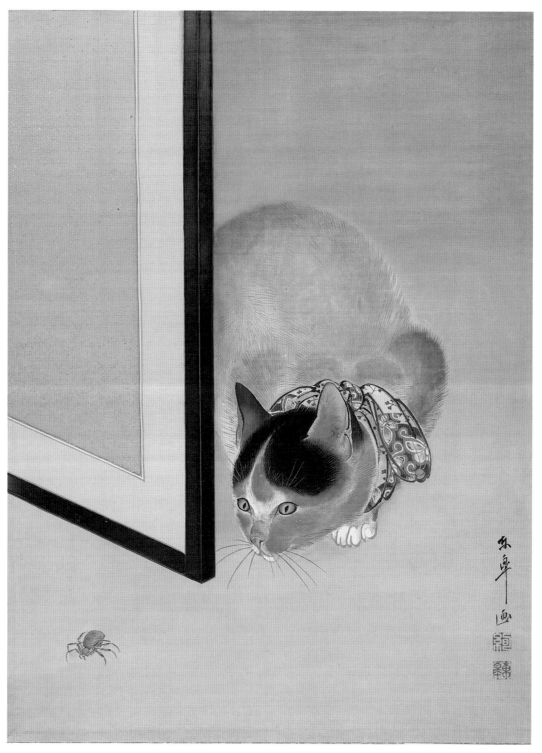

**Cat Watching a Spider,
ca. 1888–92**

ŌIDE TŌKŌ

Japanese
Album leaf; ink and color on silk

Cat Watching a Spider

JULIE FOGLIANO

so silent and certain
a spider
can cause
a watchful and wondering cat
to pause

all prowl and prance
and teeth and claws

Resistance
CYNTHIA COTTEN

He calls himself a handler,
this puny person
with his rope, his shouts,
his "I am your master"
attitude.

Thinks he can subdue me,
stifle my spirit,
bend me
to
his will.

But no, I say,
no!
I will not be broken,
controlled,
tamed.

Let others trot willingly
towards servitude,
obedience,
confinement—
towards mere
existence.

I choose life.
Alone
in the light of my
magnificence,
I will fight
until no fight
remains.

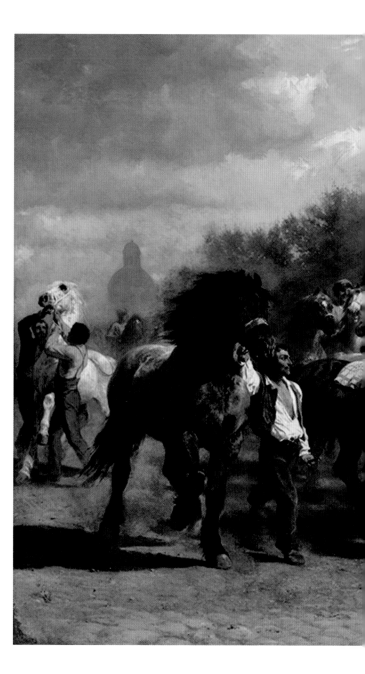

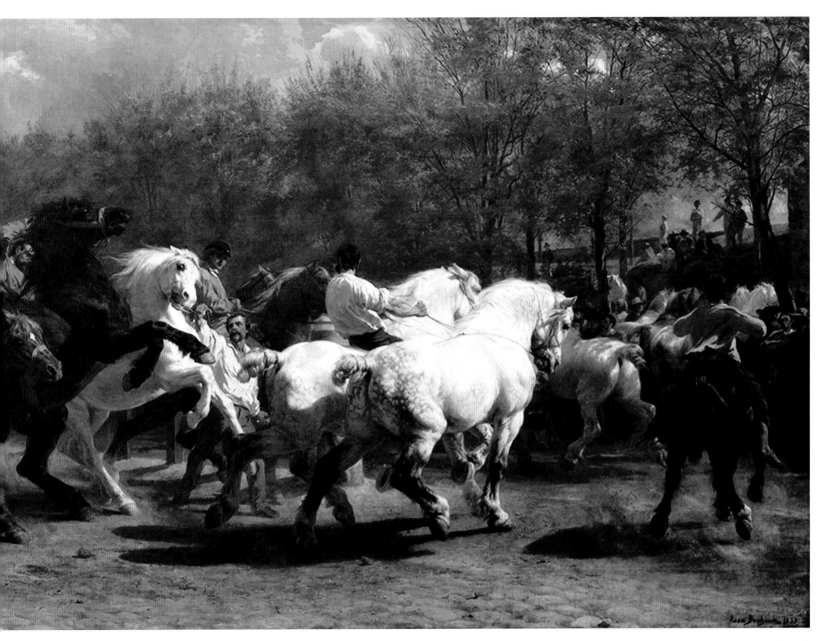

The Horse Fair, 1852–55
ROSA BONHEUR

French
Oil on canvas

Night-Shining White
ELAINE MAGLIARO

I am a charger,
 a heavenly steed—
 best of my breed.
I am a dragon
 in horsey disguise,
 flashing fire through my eyes.

My sweat is blood-red.
 The mane on my head
 stands stiff as a crown.
I prance through a town,
 my emperor astride me.
 How he loves to ride me—
 parade me around,
 as my hooves stomp the ground.

I am a charger,
 a stout-hearted steed.
I race into battle—
 taking the lead.
The emperor's favorite,
 I don't fear a fight.
I'm daring and brave.

I *am*
 Night-Shining White.

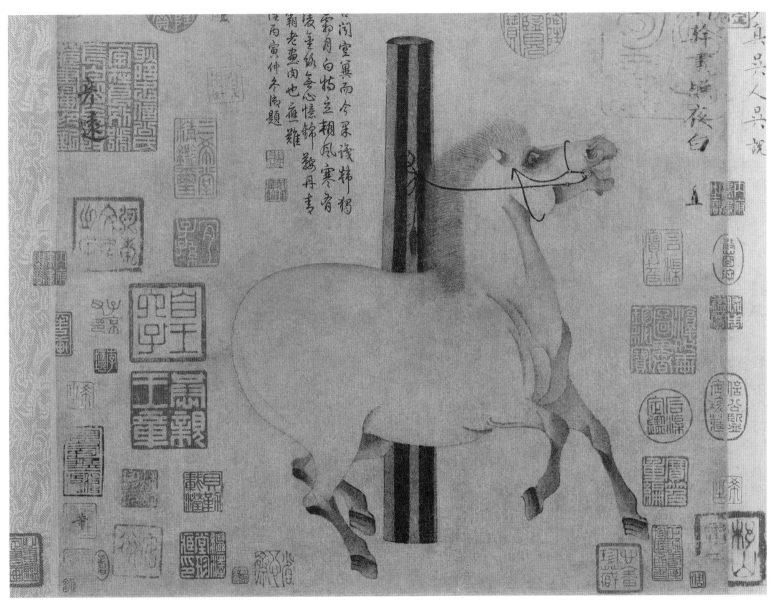

Night-Shining White, ca. 750
HAN GAN

Chinese
Handscroll; ink on paper

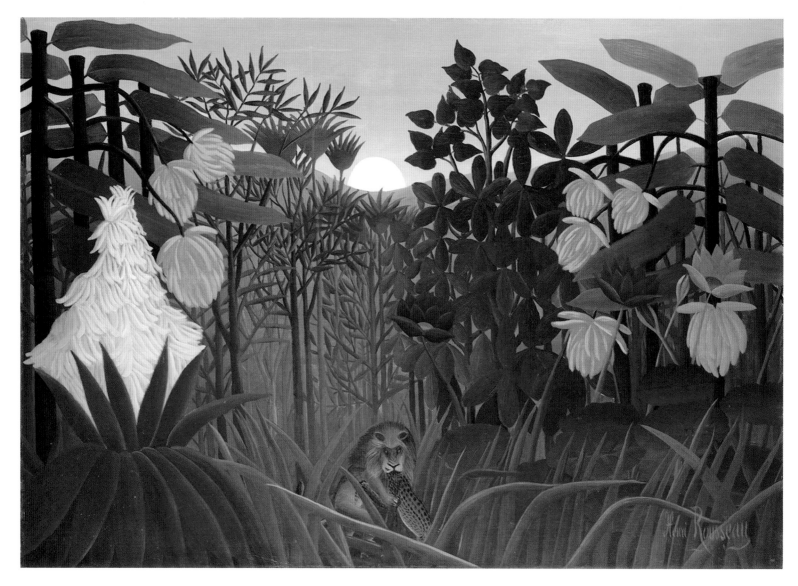

The Repast of the Lion, ca. 1907
HENRI ROUSSEAU (LE DOUANIER)

French
Oil on canvas

The Repast of the Lion

J. PATRICK LEWIS

Surprised by moon when at his ease,
A lion spies among the trees
Of his green-going paradise
A jaguar, foiled by his disguise.

The lion puts on fierce display
His fascination for the prey
That other nights on other dunes
Ruthlessly reddens other moons.

Now that he's fed and jaguar-full—
Finally his appetite is dull—
He's satisfied the wicked part
Of his corrupted lionheart.

Whatever reasons there may be
For this invented scenery,
When midnight dozes into dawn,
The lion lingers, and moves on.

Great Indian Fruit Bat

JOAN BRANSFIELD GRAHAM

As my wings whisk me, swooping through
this black velvet night, who will admire
my elegant attire, the intricacy
of my design, robed
so regally?

Ripe succulent fruit spices the air.
A royal banquet . . . a feast
spread out before me –
nectars of the night.
I rule these hours
of darkness.

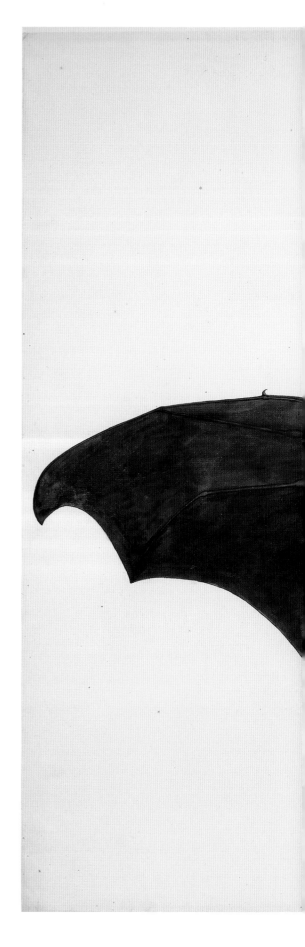

Great Indian Fruit Bat, ca. 1777–82
PAINTING ATTRIBUTED TO BHAWANI DAS OR A FOLLOWER

Indian
Pencil, ink, and opaque watercolor on paper

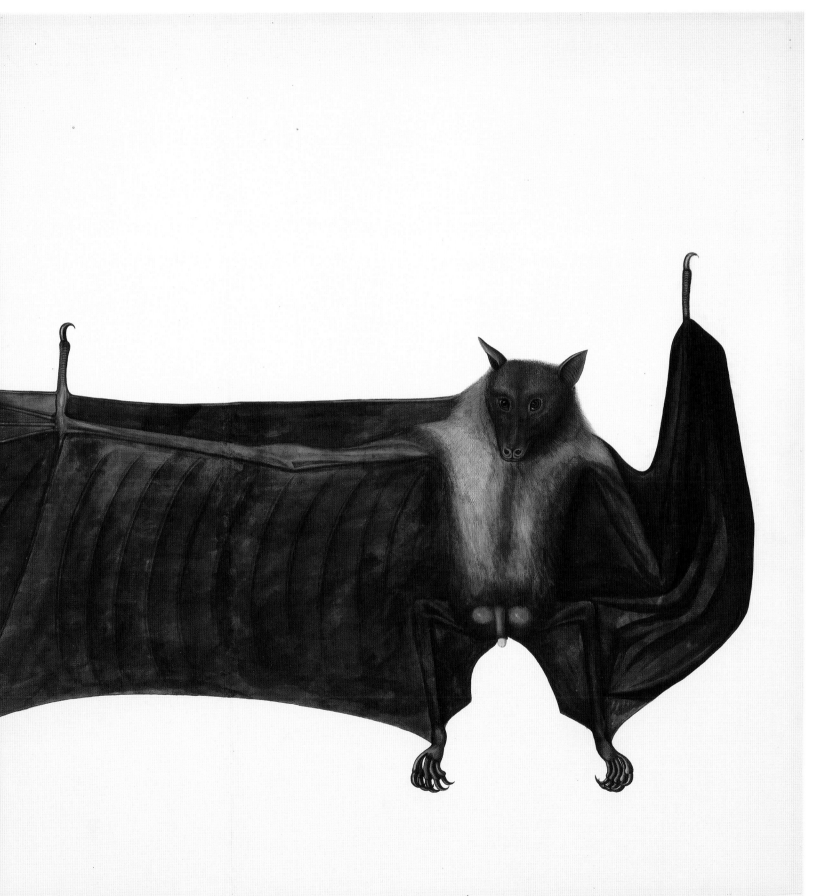

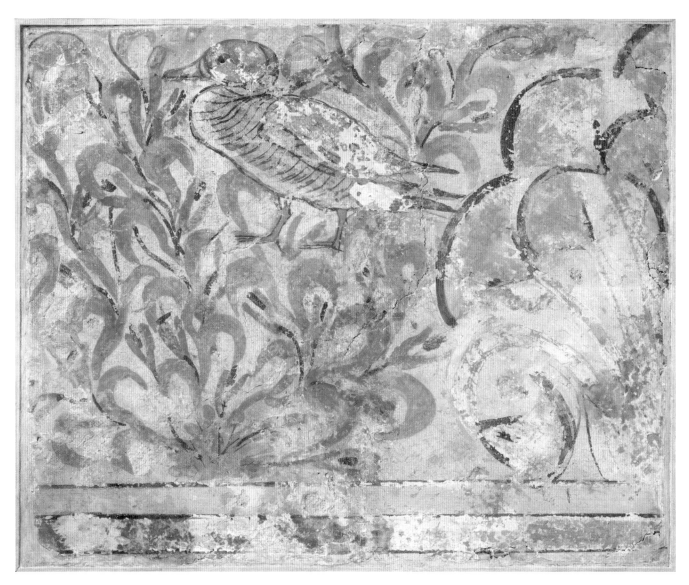

***Painted Plaster Pavement Fragment,* ca. 1390–1353 BC**

ANONYMOUS

Egyptian
Painted Plaster Pavement Fragment
Stucco with blue, green, yellow,
and brown pigments

This Is the Hour

IRENE LATHAM

This is the hour
when sun dreams,
when river
sings
its silky song.

This is the hour
Duck wades
into warm
whispery grass,
settling
onto its nest.

This is the hour
Duck asks:

What is yours?
What is
mine?

River answers:

Look how
your wings
glisten.

How my eyes
wink.

Yes, Duck says.

Now I see—
this is the hour
almighty sun
gives itself

to everything.

Early Evening
CHARLES GHIGNA

We are rowing our way
across a small, stretched
canvas of time

into the shadows
of a water colored world
where we float as in a dream,

soft and serene,
beyond the touch of our master's hand
into the final stroke of everlasting light.

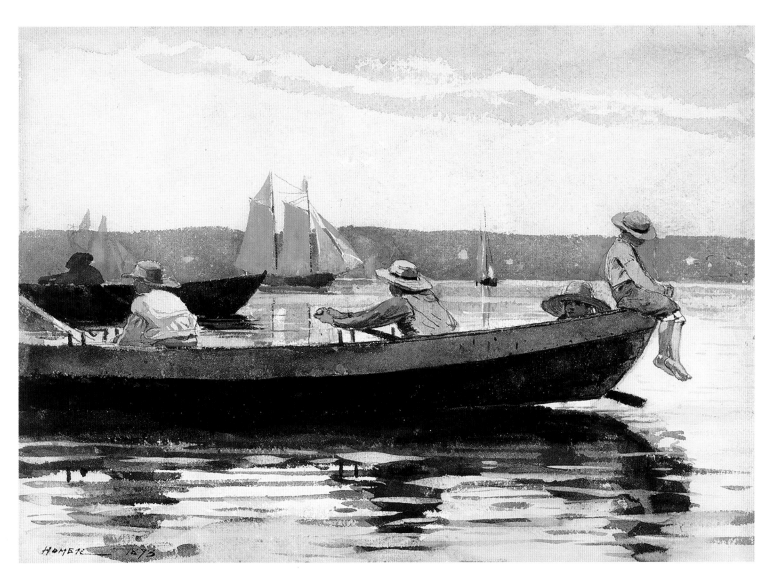

Boys in a Dory, 1873

WINSLOW HOMER

American
Watercolor washes and gouache over
graphite underdrawing on medium rough
textured white wove paper

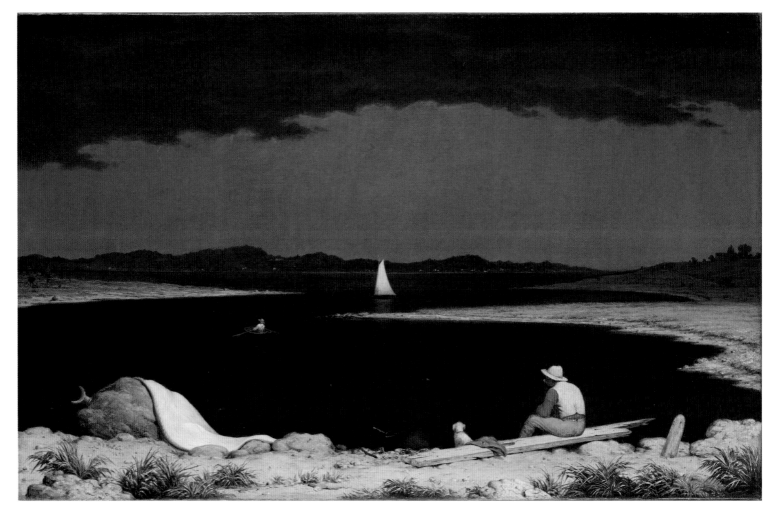

Approaching Thunder Storm, 1859

MARTIN JOHNSON HEADE

American
Oil on canvas

My Dog and I
ANN WHITFORD PAUL

My dog and I
sit,
 watch
the tufted cloud quilt
spread overhead,
hiding the listless sun,
painting the leaden sky
dull
 dark,
 dreary.

My dog and I should leave
before that quilt
 spills its chilly wet.

But here we sit,
my dog and I,
each waiting
for the other
to make
the first move.

Studio

MARILYN NELSON

In this space quiet as a laboratory,
artists as focused as the kitchen staff
of a 4-star Michelin Guide restaurant
give themselves up to organized chaos.
They were born with a compulsion
deeper than skin-deep, deeper than black:
Every cell of their bodies says *Make Art.*
Their hearts repeat: *Make Art, Make Art, Make Art.*

Here in the studio's silence
artists demonstrate that freedom means
exploring unlimited potential,
playing a part in creation.
How beautiful the human body is.
How complex light is on black skin.
How a story can emerge from colors.
How a yellow curve can become a dog.

Whether you're a woman, whether you're black,
no matter who you are, you can make art.
Art rebuilds our hope for a shared future,
it restores our courage, revives our faith.
Here in the studio, as on cave walls,
our species reaches toward undying truths.
Every work of art was once unfinished:
part in this world, part imagined.

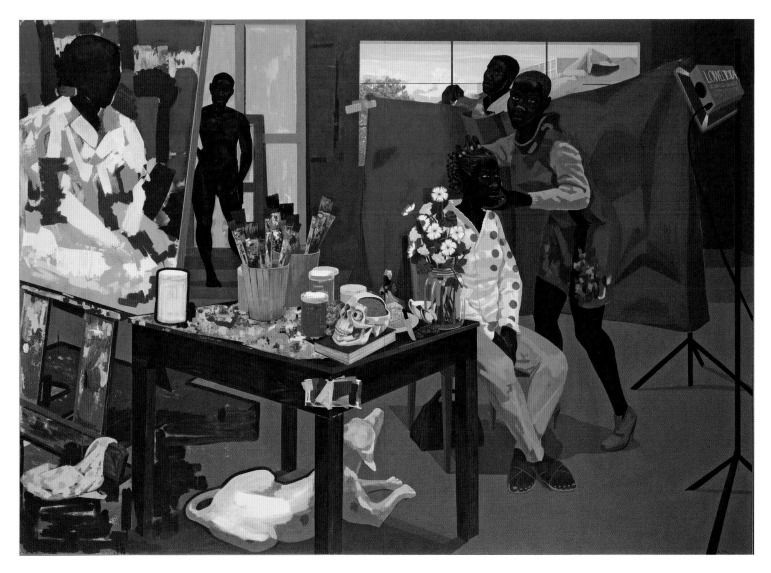

Untitled (Studio), 2014

KERRY JAMES MARSHALL

American
Acrylic on PVC panels

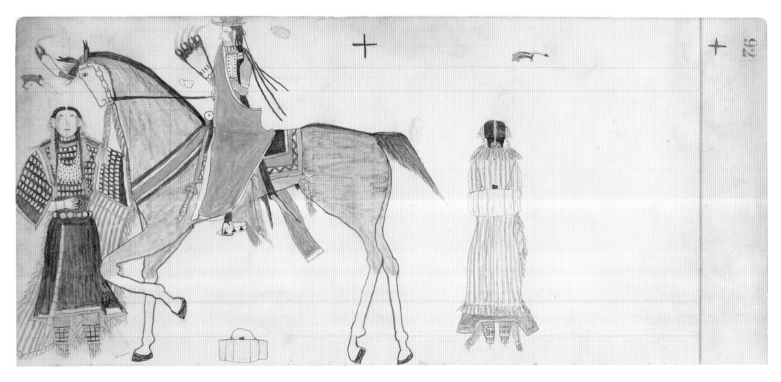

Man and Two Women (Henderson Ledger Artist B), ca. 1882

FRANK HENDERSON

Native American, Hinono'eiteen (Arapaho)
Pencil, colored pencil, and ink on paper

Our People

CAROLE BOSTON WEATHERFORD

We call ourselves *Inuna-Ina*, Our People.
We worship *Be He Tieht*, the Man Above,
And do the Sun Dance to hail summer.

The ancestors chanted the Ghost Dance
And followed buffalo across the plains,
Roaming present day Nebraska, Kansas,
Wyoming, Minnesota and Colorado.
They allied with the Cheyenne,
Warred with the Ute, Pawnee and Shoshone
And made peace with the Sioux, Kiowa and Comanche.

Our People pitched tepees in a circle.
They fished, hunted elk and deer,
And ate jerky and wild berries
After the White Owl brought winter.
The Whirlwind Woman not only gave us breath;
She gave us quillwork, embroidery.
Our every stitch, a prayer.

Kinryūsan Temple at Asakusa, 1856
UTAGAWA HIROSHIGE

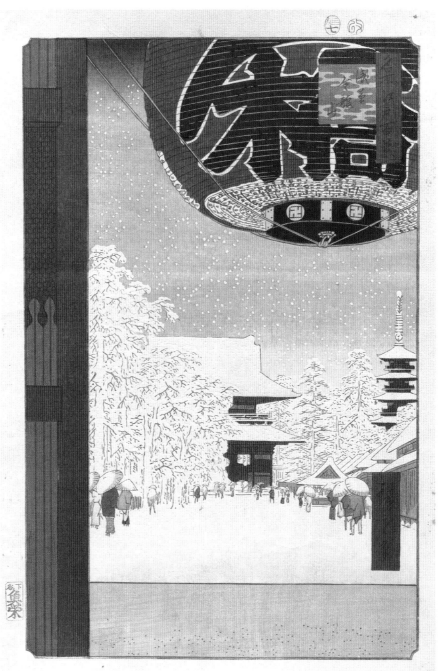

Japanese
From the series "One Hundred
Famous Views of Edo," 1856
Polychrome woodblock print;
ink and color on paper

Walking to Temple

JANET WONG

Here
we do not rush
in the random way
many people do outside the gates:
shoes shoveling
unevenly through
slush, criss-crossing
in all directions.

Here
we stay in lanes
smoothed down
by those who have
gone before us
placing
each careful step
on a path
already made firm.

It's All Magic

NAOMI SHIHAB NYE

What time is it?

Time to be kinder.

Elephants carry time in their trunks
and ruddy strong skin. They stand still
while we look at them. We just pretend to be
in charge. A bird sounds the alarm—every half hour,
it whistles. Time to touch and be touched by animal patience.

We think the days are ours, but ask a flower.
How much time do you have? More than the friendly
dragon serpent spinning and stretching
from a tiny golden pot? See the chain of little links
dangling down? Magic and facts, woven
and stacked. Think how a whole life grows,
from a baby wrapped in a swaddling blanket, to someone
running fast, to you! Each day
connected to another, each circle of minutes
fattening up an hour, and the man with the hammer
on the elephant's head thinks he makes it happen.

But the bird knows the truth.

"The Elephant Clock," 1315

ARTIST UNKNOWN

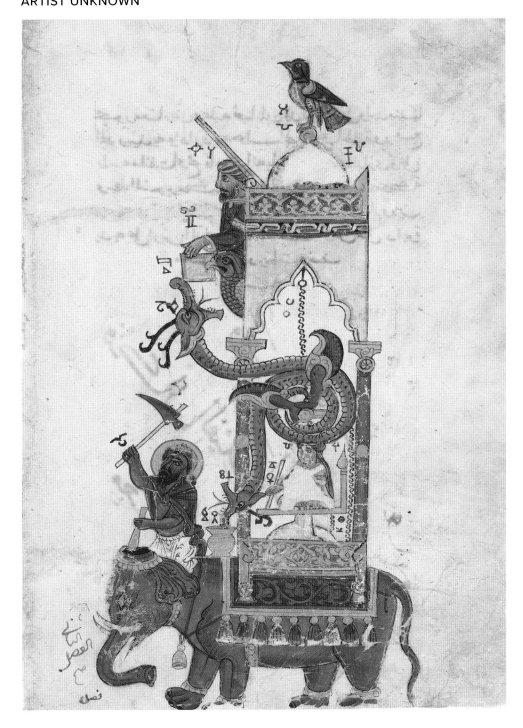

Syrian
Folio from a Book of the
Knowledge of Ingenious
Mechanical Devices by
al-Jazari, 1315
Ink, opaque watercolor,
and gold on paper

About the Poets

ALMA FLOR ADA is the author of numerous books for children and adults. In addition to receiving the Pura Belpré Award, she was honored by the Government of Mexico with the Ohtli Award for services to Mexican communities in the United States. She lives in California.

CYNTHIA COTTEN is the author of many books for children including *The Book Boat's In*, recipient of the Oppenheim Toy Portfolio Gold Award. Her poetry appears in several award-winning anthologies. She lives in New York.

REBECCA KAI DOTLICH, a prolific writer, has published many collections of poetry. She is also the author of several picture books including *One Day, The End.*, a Boston Globe-Horn Honor Book. She lives in Indiana.

JULIE FOGLIANO published her first book of poetry, *When Green Becomes Tomatoes: Poems for All Seasons*, in 2016. She is also author of several picture books. She lives in New Jersey.

CHARLES GHIGNA, fondly known as "Father Goose," is the author of several award-winning titles. He lives in Alabama.

JOAN BRANSFIELD GRAHAM is an award-winning poet whose work is widely anthologized. Her book of concrete poems, *Splish Splash*, was a *School Library Journal* Best Book of the Year. She lives in California

LEE BENNETT HOPKINS was inducted into the Florida Artists Hall of Fame in 2017. He holds a *Guinness Book of Records* citation for compiling the most anthologies for children. He has also received the Christopher Award, the Regina Medal, and the National Council of Teachers of English Excellence in Poetry for Children Award. He lives in Florida.

IRENE LATHAM received the 2016 Lee Bennett Hopkins/International Literacy Association Promising Poet Award for her first book of poetry, *Dear Wandering Wildebeest and Other Poems from the Water Hole*. She lives in Alabama.

J. PATRICK LEWIS, a prolific writer, received the National Council of Teachers of English Excellence in Poetry for Children Award. He became the third United States Children's Poet Laureate (2011–13). He lives in Ohio.

ELAINE MAGLIARO, a former elementary teacher and school librarian, published her first collection of poetry, *Things to Do*, in 2017. She lives in Massachusetts.

GUADALUPE GARCIA MCCALL wrote her first verse novel, *Under the Mesquite*, in 2011, which received a host of awards including the Pura Belpré Award and the Lee Bennett Hopkins/International Literacy Association Promising Poet Award. She lives in Texas.

MARILYN NELSON has received numerous awards for her work for both children and adult readers including the Poetry Society of America's Robert Frost Medal. She is the recipient of the 2017 National Council of Teachers of English Excellence in Poetry for Children Award.

Her verse novel, *Carver: A Life in Poems*, is a Newbery Honor Book. She lives in Connecticut, where she earned the title of Poet Laureate of the state.

NAOMI SHIHAB NYE is a multi-award winning poet. Her collection, *19 Varieties of Gazelle: Poems of the Middle East*, was a finalist for the National Book Award. She lives in Texas.

ANN WHITFORD PAUL writes poetry for children, picture books, and the professional book *Writing Picture Books: A Hands-On Guide from Story Creation to Publication*. Her poems appear in major anthologies. She lives in California.

MARILYN SINGER, a prolific author who writes in a variety of genres, is recipient of the National Council of Teachers of English Excellence in Poetry for Children Award. She divides her time between New York and Connecticut.

AMY LUDWIG VANDERWATER received high acclaim with her first book of poetry, *Forest Has a Song*, which received the Society of Children's Book Writers and Illustrators Lee Bennett Hopkins Poetry Award. She lives in New York.

CAROLE BOSTON WEATHERFORD is an acclaimed biographer of books for young readers highlighting the lives of Billie Holiday, Leontyne Price, and Lena Horne. Her book *Moses: When Harriet Tubman Led Her People to Freedom* is an NAACP Image Award and a *New York Times* bestseller. She lives in North Carolina.

JANET WONG, a former lawyer, writes picture books and poetry for children, many based on her Asian American experiences. She is a popular speaker at various literary events throughout the country. She lives in New Jersey.

About the Artists

ANONYMOUS This image of a duck in grasses was painted over 3,000 years ago by an artist whose name is not known. It is a fragment of a painting created for a decorative floor in a palace of the Egyptian king Amenhotep III.

ROSA BONHEUR (1822–99) lived and painted in France when women had limited opportunities to become professional artists. Because she did not have access to life drawing classes, she studied the anatomy of animals and is known for her highly realistic depictions of them.

FERNANDO BOTERO (born 1932) is a Colombian painter and sculptor. It was during travels to Europe in the 1950s that he was first exposed to art of the great Renaissance masters, as well as to modern movements such as Cubism and Surrealism. His own work reflects all of these influences but has a distinctive Latin American style.

MARY CASSATT (1844–1926) was the only American artist to exhibit her work with the original group of French Impressionists. Her compositions were influenced by the work of Edgar Degas and Edouard Manet. She was especially interested in showing the relationship between adults and children.

LIBERALE DA VERONA (ca. 1445–1527) was an Italian artist who worked during the Renaissance, a period known for a great flourishing of the arts. In addition to painting in tempera on wooden panels, he was also a brilliant illustrator of choir books.

LEONARDO DA VINCI (1452–1519) is one of the most intriguing personalities in the history of Western art. Trained in Florence as a painter and sculptor in the workshop of Andrea del Verrocchio (1435–1488), Leonardo is also celebrated for his scientific contributions. Leonardo's curiosity and insatiable hunger for knowledge never left him. He was constantly observing, experimenting, and inventing, and drawing was, for him, a tool for recording his investigation of nature. Although completed works by Leonardo are few, he left a large body of drawings that record his ideas, most still gathered into notebooks. His genius as an artist and inventor continues to inspire artists and scientists alike, even centuries after his death.

BHAWANI DAS (active second half of the eighteenth century), a practitioner of Company Art, created primarily for the British employees of the East India Company. He combined a traditional Mughal style with elements of European art.

DEVIDASA OF NURPUR (active ca. 1680–1720) was born into a family of artists in the Punjab region of India. Like his father before him and his son after him, he made illustrations for a fifteenth-century Sanskrit love poem.

HAN GAN (active ca. 742–56) lived in China under the reign of Emperor Xuanzong, during the Tang Dynasty. He was well-known for his dramatic, lifelike portraits of horses. Essential to Chinese life for many centuries, horses were especially valued during this period, as symbols of imperial power.

MARTIN JOHNSON HEADE (1819–1904), born in Pennsylvania, had a keen interest in nature. His landscapes often focused on storms. Many of his still life paintings were exquisitely detailed studies of exotic

birds, flowers, and foliage that he saw on trips to the tropics of South and Central America.

FRANK HENDERSON (1862–85) was a Native American from the Arapaho tribe of the Great Plains. He created ledger drawings, named for the ledger (or account) books that became the main source of paper for Native Americans who were imprisoned or relocated to reservations.

UTAGAWA HIROSHIGE (1797–1858) was a Japanese artist who lived and worked during the Edo Period. His colorful woodblock prints, especially his series entitled "One Hundred Famous Views of Edo," had a great influence on Western artists such as Van Gogh and Degas.

WINSLOW HOMER (1836–1910) is one of the most important American artists of the nineteenth century. He was a master of both oil and watercolor painting. His subjects ranged from depictions of returning soldiers and emancipated slaves after the Civil War to the more lighthearted scenes of leisure by the sea.

GUSTAV KLIMT (1862–1918) was an Austrian artist and founding member of the Vienna Secession, a group of artists who sought to break away from artistic traditions. Klimt's work is loosely related to Symbolism and Art Nouveau, styles developing during the same period in other parts of Europe.

KERRY JAMES MARSHALL (born 1955) grew up in Los Angeles. In his monumental pictures, using bold colors and shapes, the artist challenges stereotypes and tells often-invisible stories of African American experience. Marshall currently lives in Chicago.

JOSÉ GUADALUPE POSADA (1851–1913) was a Mexican printmaker whose most famous works were "calaveras," amusing images of skeletons involved in everyday activities. These illustrations were published for El Día de Muertos, a holiday that celebrates the lives of friends and family who have died.

HENRI ROUSSEAU (1844–1910), born in France, was called "Le Douanier" because of his profession as a customs official. He

was a self-taught artist who loved to paint jungle scenes, although he never visited one himself. His work had enormous influence on artists who followed him, such as Pablo Picasso and Fernand Léger.

ŌIDE TŌKŌ (1841–1905) was a Japanese artist who worked during the Meiji Period, a time of dramatic change. After more than 200 years of isolating itself, in 1853 Japan opened its borders and actively engaged in trade with the outside world.

UNKNOWN (C. 1315) This representation of a mechanical device was painted in Syria in the fourteenth century. It illustrates one of the inventions (probably never built) described in a book written approximately 100 years earlier. While the name of the book's calligrapher is known, the name of the painter is not.

Credits

Poetry

All the poems were especially commissioned for this book. Thanks are due to the following for use of works in this collection: Curtis Brown, Ltd. for "Blue Worlds" by Rebecca Kai Dotlich. Copyright © 2018 by Rebecca Kai Dotlich; "Endgame" by Lee Bennett Hopkins. Copyright © 2018 by Lee Bennett Hopkins; "Young Ashoka Sundari" by Amy Ludwig VanDerwater. Copyright © 2018 by Amy Ludwig VanDerwater; All used by permission of Curtis Brown, Ltd. All other works are used by permission of the respective authors, who control all rights; all copyright © 2018. Alma Flor Ada for "Dancing"; Cynthia Cotten for "Resistance"; Julie Fogliano for "Cat Watching a Spider"; Joan Bransfield Graham for "Great Indian Fruit Bat"; Charles Ghigna for "Early Evening"; Irene Latham for "This Is the Hour"; J. Patrick Lewis for "The Repast Of The Lion"; Elaine Magliaro for "Night-Shining White"; Guadalupe Garcia McCall for "Ti-ki-ri, ti-ki-ri, ti-ki-ri, tas!"; Marilyn Nelson for "Studio"; Naomi Shihab Nye for "It's All Magic"; Ann Whitford Paul for "My Dog and I"; Marilyn Singer for "Paint Me"; Carole Boston Weatherford for "Our People"; Janet Wong for "Walking to Temple."

Art

A Bear Walking, ca. 1482–85
Leonard da Vinci
Silverpoint on light buff prepared paper
4 1/16 x 5 1/4 in. (10.3 x 13.3 cm)
Robert Lehman Collection, 1975
1975.1.369

Mäda Primavesi, 1912–13
Gustav Klimt
(Austrian, Baumgarten 1862–1918 Vienna)
Oil on canvas
59 x 43 1/2 in. (149.9 x 110.5 cm)
Gift of André and Clara Mertens, in memory of her mother, Jenny Pulitzer Steiner, 1964
64.148

Young Mother Sewing, 1900
Mary Cassatt
(American, Pittsburgh, Pennsylvania 1844–1926 Le Mesnil-Théribus, Oise)
Oil on canvas
36 3/8 x 29 in. (92.4 x 73.7 cm)
H.O. Havemeyer Collection, Bequest of Mrs. H.O. Havemeyer, 1929
29.100.48

The Chess Players, ca. 1475
Liberale da Verona
(Italian, Verona ca. 1445–1527/29 Verona)
Tempera on wood
Overall 13 3/4 x 16 1/4 in. (34.9 x 41.3 cm); painted surface 13 1/8 x 15 7/8 in. (33.3 x 40.3 cm)
Maitland F. Griggs Collection, Bequest of Maitland F. Griggs, 1943
43.98.8

Shiva and Parvati Playing Chaupar: Folio from a Rasamanjari Series, 1694–95
Devidasa of Nurpur
(Indian, Basohli, Jammu, India, active ca. 1680–1720)
Opaque watercolor, ink, silver, and gold on paper
Image: 6 1/2 x 10 7/8 in. (16.5 x 27.6 cm)
Sheet: 8 x 12 1/4 in. (20.3 x 31.1 cm)
Framed: 15 5/8 x 20 1/2 in. (39.7 x 52.1 cm)
Gift of Dr. J. C. Burnett, 1957
57.185.2

Dancing in Colombia, 1980
Fernando Botero
(Colombian, born 1932)
Oil on canvas
74 x 91 in. (188 x 231.1 cm)
Anonymous Gift, 1983
© Fernando Botero
1983.251

Skeletons as artisans, ca. 1890–1910
José Guadalupe Posada
(Mexican, 1851–1913)
Wood engraving
Sheet: 4 3/4 × 7 1/2 in. (12 × 19 cm)
Gift of Jean Charlot, 1930
30.82.1

Cat Watching a Spider, ca. 1888–92
Ōide Tōkō
Meiji period (1868–1912)
Japan
Album leaf; ink and color on silk
14 3/4 x 11 in. (37.5 x 27.9 cm)
Charles Stewart Smith Collection, Gift of Mrs. Charles Stewart Smith, Charles

Stewart Smith Jr., and Howard Caswell
Smith, in memory of Charles Stewart Smith,
1914
14.76.61.73

The Horse Fair, 1852–55
Rosa Bonheur
(French, Bordeaux 1822–1899 Thomery)
Oil on canvas
96 1/4 x 199 1/2 in. (244.5 x 506.7 cm)
Gift of Cornelius Vanderbilt, 1887
87.25

Night-Shining White, ca. 750
Han Gan
(Chinese, active ca. 742–756)
Tang dynasty (618–907)
China
Handscroll; ink on paper
Image: 12 1/8 x 13 3/8 in. (30.8 x 34 cm)
Overall with mounting: 14 in. x 37 ft. 5 1/8 in.
(35.4 cm x 11.4 m)
Purchase, The Dillon Fund Gift, 1977
1977.78

The Repast of the Lion, ca. 1907
Henri Rousseau (le Douanier)
(French, Laval 1844–1910 Paris)
Oil on canvas
44 3/4 x 63 in. (113.7 x 160 cm)
Bequest of Sam A. Lewisohn, 1951
51.112.5

Great Indian Fruit Bat, ca. 1777–82
Painting attributed to Bhawani Das or a
follower (Indian, active ca. 1850–1900)
Illustrated single work
Made in India, Calcutta

Pencil, ink, and opaque watercolor on paper
Painting: 23 1/2 x 32 3/4 in. (59.7 x 83.2 cm)
Mat size: 27 1/4 x 35 1/2 in. (69.2 x 90.2 cm)
Purchase, Anonymous Gift, Cynthia Hazen
Polsky Gift, Virginia G. LeCount Bequest,
in memory of The LeCount Family, 2007
Benefit Fund, Louis V. Bell, Harris Brisbane
Dick, Fletcher, and Rogers Funds and
Joseph Pulitzer Bequest, and Gift of Dr.
Mortimer D. Sackler, Theresa Sackler and
Family, 2008
2008.312

Boys in a Dory, 1873
Winslow Homer
(American, Boston, Massachusetts 1836–
1910 Prouts Neck, Maine)
Watercolor washes and gouache over
graphite underdrawing on medium rough
textured white wove paper
9 3/4 x 13 7/8 in. (24.8 x 35.2 cm)
Bequest of Molly Flagg Knudtsen, 2001
2001.608.1

Approaching Thunder Storm, 1859
Martin Johnson Heade
(1819–1904)
Oil on canvas
28 x 44in. (71.1 x 111.8cm) Framed: 42 1/2 ×
58 3/8 × 5 in. (108 × 148.3 × 12.7 cm)
Gift of Erving Wolf Foundation and Mr. and
Mrs. Erving Wolf, in memory of Diane R.
Wolf, 1975
1975.160

Untitled (Studio), 2014
Kerry James Marshall
(American, born Birmingham, Alabama
1955)
Acrylic on PVC panels
83 5/16 × 119 1/4 in . (211.6 × 302.9 cm)
Purchase, The Jacques and Natasha
Gelman Foundation Gift, Acquisitions
Fund and The Metropolitan Museum of
Art Multicultural Audience Development
Initiative Gift, 2015
© Kerry James Marshall
2015.366

*Man and Two Women (Henderson Ledger
Artist B)*, ca. 1882
Frank Henderson
(Native American, Hinono'eiteen (Arapaho),
1862–1885)
Pencil, colored pencil, and ink on paper
5 3/8 x 11 7/8 in. (13.7 x 30.2 cm)
Other: 5 3/8 in. (13.7 cm)
Gift of Charles and Valerie Diker, 1999
1999.484.17

Kinryūsan Temple at Asakusa, from the
series "One Hundred Famous Views of
Edo," 1856
Utagawa Hiroshige
(Japanese, Tokyo (Edo) 1797–1858 Tokyo
(Edo))
Polychrome woodblock print; ink and color
on paper
14 1/16 x 9 1/2 in. (35.7 x 24.1 cm)
The Howard Mansfield Collection,
Purchase, Rogers Fund, 1936
JP2519

Index